Watercolor

WITH JOAN HANSEN, CAROLINE LINSCOTT,
AND WILLIAM F. POWELL

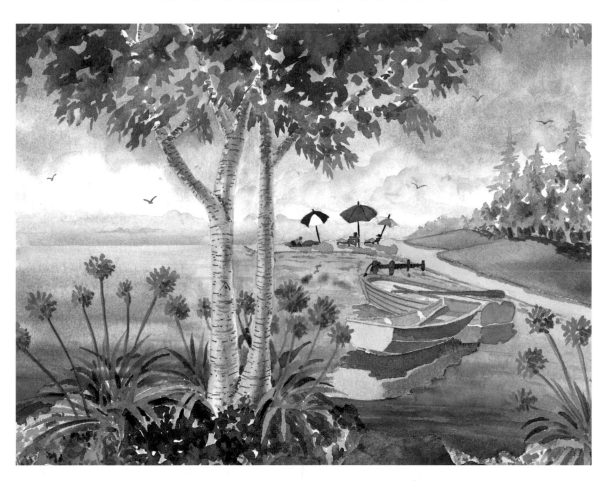

Contents

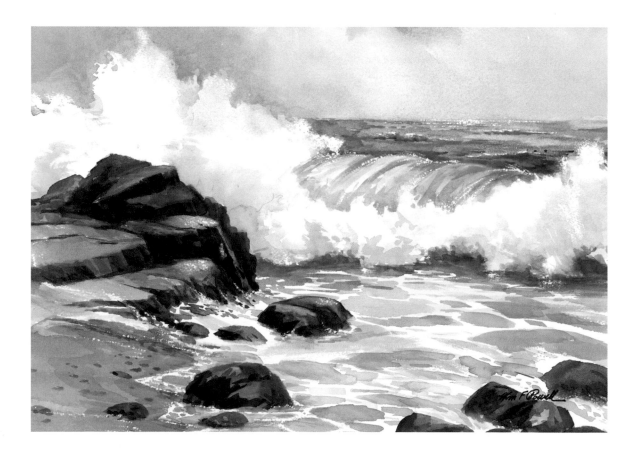

Introduction

Watercolor is a versatile medium that affords artists a great amount of freedom in regard to subject matter and painting styles. Watercolor painting techniques can vary from broad, sweeping washes of color to fine, tightly detailed subjects. You easily can combine loose, impressionistic techniques with photorealistic methods. Or, with planning, you can create deep, richly colored works by painting many transparent layers over previously applied colors.

Even though each artist individualizes his or her paintings with a personal impression of the subject and color, most artists follow the same basic steps to begin painting. First they choose a subject, either using a photograph for reference or painting from life. (Few artists paint from memory or their imaginations.) Then they sketch out the subject on paper, determining the composition, or how the elements are arranged in relation to one another. (A good composition should be pleasing to the eye, taking into account the relationships between negative and positive spaces, as well as principles such as unity, conflict, repetition, balance, and harmony.) Then most artists use pencil or charcoal to lightly block in the basic shapes of the composition on the painting surface. Finally they apply color.

Applying color is the most exciting part of painting. The ability to see color and the lights and darks in color is one of the most marvelous senses we possess because it opens the door to unlimited avenues of expression. It is the contrasting lights and darks within a painting that create the illusion of dimension (or form) on the flat surface. Color can be manipulated in an endless number of exciting ways to produce unique and expressive works of art.

These lessons will provide an excellent start to experiencing the art of watercolor painting. Just remember: Practice will be the key to your success, and your skills will improve with perseverance. Happy painting!

Tools and Materials

Watercolor Paints

Watercolor paints are available in three forms—in tubes, in small plastic or metal containers known as "pans," and in blocks of color called "cakes," which are used to refill pans. Most artists choose tube watercolors because they are already moist and allow you to squeeze out a large amount of color quickly, making them easy to use. Pan and cake paints, however, are small and light, which make them ideal for travel. Reeves watercolor paints are available in both tube and pan styles; you can find them packaged in convenient sets at your local art and craft store. The projects in this book use burnt sienna, magenta (equivalent to alizarin crimson), yellow ochre, lemon yellow, ultramarine (blue), and cerulean blue hue. In theory, you can mix these six colors to create just about any other color (see pages 6–7 for more about color mixing), but in practice its best to start with a small array of colors. Note that white paint is not used in these projects; traditionally, watercolorists use the white of the paper rather than opaque white paint.

Flat Brushes

One of the most common style of brushes used with watercolor is the flat brush. A flat brush has bristles of equal length, which are usually about 1-1/2 times the width of the ferrule (the metal band that holds the bristles). The flat is an important tool for covering large areas and applying washes. You can also use the tip and corners of the flat brush to produce fine detail. Reeves produces a variety of watercolor paintbrushes, including flat brushes in varied sizes and hair types. The size of each brush is indicated by a number (a smaller number indicates a smaller-sized brush), and brush hair type is categorized as either natural or synthetic.

Round Brushes

Round brushes are also commonly used with watercolor. The hairs of a round brush taper gradually to a fine point, and this design allows the brush to hold a large amount of water and color. The round brush can also create a variety of strokes. You can pull the brush to make long strokes or stroke with the brush along its side for broad, sweeping effects. You can even use the tip of the round to "draw" fine details. Check out your local art and craft store for a selection of Reeves round brushes in varied sizes and hair types.

Watercolor Paper

Watercolor paper is categorized by weight, size, and surface texture. Generally weights range from 72 to 400 lbs; the heavier the weight, the less tendency it has to warp when wet. Lighter-weight papers work well for smaller paintings, but for large paintings, it's wise to use papers with weights of 300 to 400 lbs. Paper texture refers to the paper's surface and varies from rough (a heavy texture) to plate-finish (a smooth surface). The most popular is a medium textured paper known as "cold pressed."

Mixing Palette

Palettes contain wells for pooling and mixing colors while painting. Palettes are available in many different materials, including glass, ceramic, plastic, and metal. All are easy to clean, but glass and ceramic palettes are heavier and usually more expensive. Palettes also come in a variety of shapes—circle, square, oval, etc.—and sizes, but they all contain multiple color wells and at least one large, flat area for mixing colors and creating washes.

Work Space

Your work station can be an elaborate structure or just a corner in a room, but two elements are absolutely essential: comfort and good lighting—natural light is best. If possible, set up your studio in a place where you'll have few distractions, and include a supportive chair. When you're comfortable, you'll be able to paint for longer stretches of time, and you'll find the overall experience more pleasant.

Other Necessities

There are a few other items you might find handy in your painting adventures. A sketchpad, pencil, and eraser are always a good idea to have on hand for quick studies and blocking in your sketch before you paint. Two jars of water, one for rinsing brushes and one for clear water washes, are essential. A toothbrush, alcohol, paper towels, and tissues each can be used to accomplish a number of interesting special effects. A spray bottle or mister will help to keep your paints (and sometimes even your paper) moist. A hair dryer can be used to reduce drying time. And you may find that masking tape and masking fluid are useful for protecting edges and saving whites.

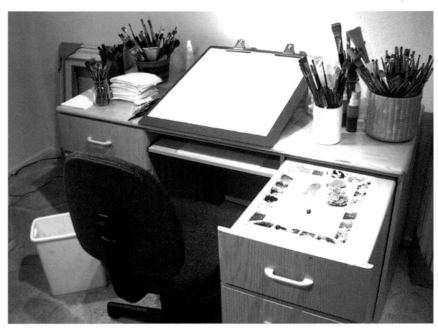

WORK STATION When you set up your work area, keep all your materials within easy reach, and make sure you have adequate artificial light if you work at night.

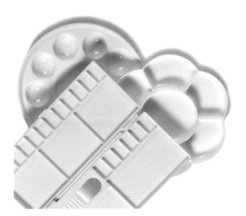

PALETTE SELECTION No matter what style of palette you choose, try to find one with a large, flat area for mixing and creating washes and one with plenty of wells for holding all your colors.

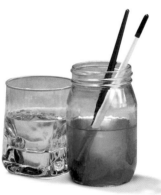

WATER CONTAINERS It's a good idea to have two water jars ready to use: one for washing brushes and the other to hold clean water for diluting your paints. If you choose to use only one jar, make it a big one and change your water often.

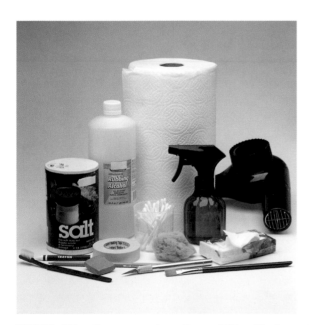

EXTRAS Although you may not use these additional tools on every painting, it's a good idea to have them on hand.

Using Frisket

Using frisket is a way of saving the white of your paper. Liquid frisket, or masking fluid, is the type most commonly used by watercolorists. To apply, dampen an old brush and stroke it over a bar of soap (the soap prevents the bristles from absorbing too much fluid); then paint the frisket over the areas you want to remain white. Wash the brush and let the frisket dry completely. To remove the dry mask, rub it gently with your finger or with a rubber eraser.

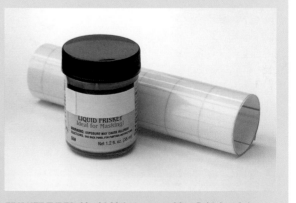

FRISKET TYPES Liquid frisket, or masking fluid, is a latex-based substance that is either white or slightly colored. (Colored mask is easier to see on white paper.) Paper frisket is a clear adhesive that you cut with scissors or a utility knife and adhere to the painting surface.

Color Theory and Mixing

Color and the Color Wheel

To mix color effectively, it helps to understand some color theory. There are three *primary* colors (yellow, red, and blue). All other colors are derived from these three. *Secondary* colors (purple, green, and orange) are each a combination of two primaries (for example, mixing red and blue makes purple). *Tertiary* colors are the results you get when you mix a primary with a secondary (red-orange, yellow-orange, yellow-green, blue-green, blue-purple, and red-purple). *Complementary* colors are any two colors directly across from each other on the color wheel. In addition, there are three other terms to remember when mixing colors—*hue,* the pure color or gradation of color; *value,* the lightness or darkness of color; and *chroma* or saturation, the strength and brightness of color.

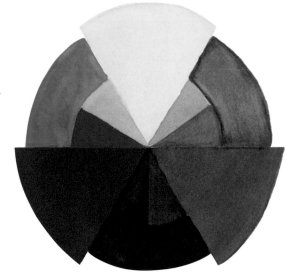

COLOR WHEEL A color wheel is a convenient visual reference for mixing colors. Knowing the fundamentals of how colors relate to and interact with one another will help you create a desired mood—as well as interest and unity—in your watercolor paintings. Note that colors on the red side of the wheel are considered to be *warm,* while colors on the blue side are *cool.*

Mixing Complements

Direct complements (such as yellow and purple, red and green, or blue and orange) can mute, or "gray," one another better than any other colors on the wheel. You also can create natural grays by mixing complements in varying amounts.

Red-purple

Red-purple + yellow-green = brownish-red

Add more yellow-green = muddy brown

Equal amounts of the two complements = gray

Add more red-purple = deep green

Yellow-green + a touch of red-purple = grayish yellow-green

Yellow-green

Analogous Colors

Any three colors next to each other on the color wheel are called "analogous colors." *Analogous* means that there is a close relationship with respect to hues. That is, the hues are similar but slightly different, as shown at right. As you look around the color wheel, you will find other groups of analogous colors. Using related groups of colors in your paintings creates a sense of *color harmony.*

BLENDING COMPLEMENTS Notice how complementary colors appear when loosely mixed on white paper. You can also mix colors on the painting itself.

WARM HUES Yellow-orange, yellow, and yellow-green are analogous to one another.

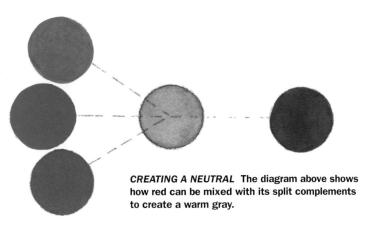

CREATING A NEUTRAL The diagram above shows how red can be mixed with its split complements to create a warm gray.

Split-Complements

Draw a straight line between two direct complements. The colors above and below a color's direct complement are called its *split-complements*. Split-complements allow for a greater range of color mixtures, and they "gray" the opposite color differently than its direct complement.

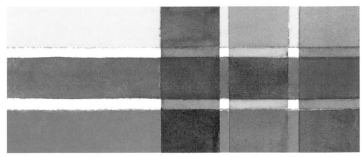

GLAZING Here strips of yellow, orange, and green were painted and allowed to dry. Thin glazes of magenta, ultramarine, and burnt sienna were painted over them.

Transparent Color Glazes

Colors can be changed or planned by building up thin *glazes*, or transparent layers. The effect of transparency results from mixing the paint with water. For example, apply a layer of paint and allow it to dry. Then paint a glaze of another color over it. The eye mixes the color visually.

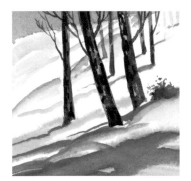 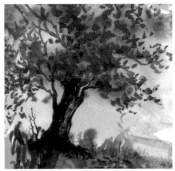

COOL COLORS Cool blues convey the quiet of this snow scene.

WARM COLORS Warm, vibrant colors express an autumn mood.

Selecting Colors

Colors should be chosen according to the painting's scene and mood. A snow scene needs cool blues, complemented by orange for accents and graying. An autumn scene requires a warmer palette of reds and oranges, complemented with greens and blues. Remember that colors on the red side of the wheel are warm while those on the blue side are cool.

Creating Moods

Color invokes emotional responses. Soothing colors are often used in work areas, schools, and hospital rooms. Color is also used to enhance product sales. Study advertisements and notice that warm, cheery colors attract attention while drab, grayed colors are not interesting.

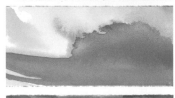

NOISE Pure complementary colors applied next to each other can be loud and unsettling.

MYSTICAL Blues and purples create a mood of mystery and foreboding.

COOLNESS Lightened cool colors result in a calm, serene feeling.

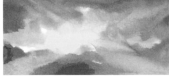

WARMTH Yellows, reds, and oranges suggest heat and warmth. Reds can imply danger.

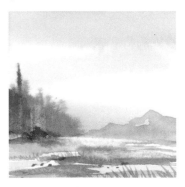

HIGH KEY A high key painting uses a lot of white and projects a soft, airy feeling.

LOW KEY A low key painting uses dark colors and is usually more somber.

Watercolor Washes

A *wash* is a thin mixture of paint that has been diluted with water. And as simple as the method may sound, washes are an integral part of watercolor painting. They can play the role of a flat backdrop to more dramatic visual elements or serve as an underpainting for further color work. They also can stand alone to convey mood and atmosphere. When washes are layered on top of one another, the technique is called "glazing," which is a great way to establish darker colors. Washes can be applied on wet or dry paper, and a combination of the two can also produce expressive results. Experiment with the various kinds of washes to see how they can work for you.

FLAT WASH The most common kind of wash used in watercolor is the flat wash. A flat wash is a simple way to fill in a large area with a solid color. Load your flat brush with water-diluted paint; then tilt the paper while you sweep slightly overlapping, horizontal strokes across the page. Maintain the same depth of color from the top to the bottom by adding more paint to your brush between strokes. Let gravity help the strokes blend together. (You can also wet the paper before applying paint for a lighter, softer wash.)

GRADED WASH Graded washes also are used quite frequently, and they're the perfect method for painting realistic water and skies. Graded washes are laid in the same way as flat washes, but more water is added to the pigment for each successive line of paint. With this technique, the color transitions from dark to light. To create a graded wash, paint horizontal strokes across the top of the tilted painting surface with a flat brush, and add water between strokes to fade out the color gradually as you work down the paper.

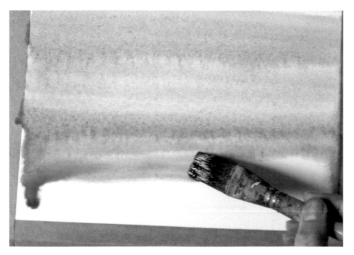

VARIEGATED WASH A variegated wash makes use of several different colors laid in uneven bands. The irregularity of the lines helps the multiple colors merge without obvious boundaries. Damp paper also encourages the color blend. Unlike other washes, the variegated wash dries with variations still intact. This technique often is used to paint sunset skies or peaceful seas.

SPONGE WASH You can use a sponge instead of a brush to paint washes as well. To apply a sponge wash, first wet the paper. Even with damp paper, the paint won't run as much with a sponge as it can with a brush. Paint the wash as you would a regular flat wash, dipping the sponge in the paint before each stroke. Continue laying in even lines until the page is covered. The slight steaks between lines of color will merge as the painting dries flat.

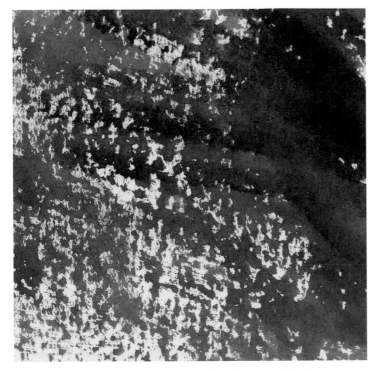

DRY WASH A dry wash is one that is laid in on dry paper. The dry paper gives you more control over the spread of the color, producing a crisper, more defined appearance. Dry washes can be used alone, or they can be applied over previous (dry) applications of color. Here a dark green mixture is drawn over a dry base of lemon yellow.

Wash Variations

The same basic techniques used for the flat wash and graded wash can be manipulated in other ways as well. You can change the appearance of your watercolor washes by blending them with preexisting layers of paint or by altering the dampness of your paper. If you're not sure how much paint to use or how damp to make your paper, try experimenting on a scrap of watercolor paper before using the technique in your painting.

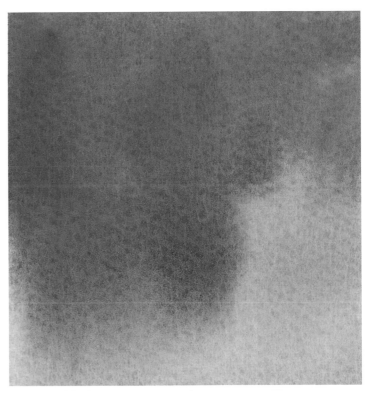

RUNNING WASH Though many colors are mixed on the palette, others are mixed on the paper itself. This multi-colored wet-into-wet wash produces a unique blend of colors by "running" the colors together. For this method, apply washes of different colors; then, while your watercolors are still wet, tilt the paper to allow the colors to run and blend together.

WET WASH Dampening your paper before you paint produces a unique effect. The colors spread unevenly, and they bleed and run freely over the wet areas of the paper, blending together to create a soft, diffused appearance. The wet wash method produces a beautiful, natural-looking sky, as demonstrated here.

Basic Watercolor Techniques

Watercolor painting boils down to one basic technique: controlling moisture. The strength of a color, the fluidity of the paint, and the texture of brushstroke are all determined by the amount of water used. But watercolor painting also uses more specialized techniques to create dynamic effects. Every technique produces a unique result, so be sure to familiarize yourself with each!

Paper Moisture

Controlling the moistness of your watercolor paper is very important. Watercolor paint will act differently depending on the paper's dampness, as shown at right. Controlling the moisture allows for greater control of techniques and color blends. Experiment on scraps of paper with varying degrees of dampness, and observe how the colors blend and react.

Saturated Paper

Semi-Moist Paper

Damp-Dry Paper

Dry Paper

Brush Moisture

You can control both the amount of moisture on your paper and on your brush. When you load your brush with a lot of water, your brush will glide smoothly and the moist paint will soak into the grains of the paper. However when you use just a bit of paint on a dry brush, you must drag the brushstroke across the support; then the pigment catches on the raised grain of the paper. Varying the amount of moisture on your brush can produce an entirely different appearance to your subject.

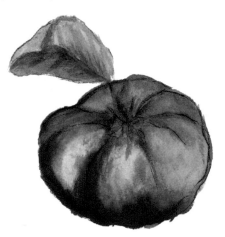

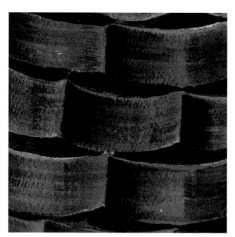

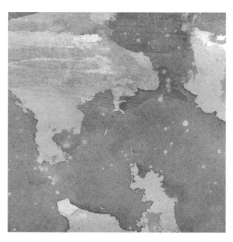

WET-INTO-WET Painting onto a wet support with a damp brush is called painting "wet-into-wet." This technique is used to achieve soft-edged objects and smooth color blends, such as the natural-looking transitions between yellow and red in this tomato. To paint wet-into-wet, use a flat brush to go over your support several times with clear water. The paper should not be dripping, but thoroughly saturated. Your brush should also be damp, but not so wet that you can't maintain some control over your edges.

DRYBRUSH As the term drybrush implies, this technique involves applying color with a dry brush—or without using water. This technique is much more precise than wet-into-wet painting; with drybrush, you can paint sharp edges and detail, in contrast to the soft, blurred edges that wet painting techniques produce. Drybrush is used to achieve texture, such as the woodlike, weathered texture of this basket weave. Drybrush also can be used to render animal fur, hair, or grass.

COMBINATION When you combine techniques and paint with a moist brush and dry paper, you gain more control over the spread of your paint. By combining methods, you can develop soft shapes, as in wet-into-wet, but with more defined edges, as shown in the example above. Most paintings combine all three techniques, beginning with the softest shapes wet-into-wet, working up to wet-on-dry, and finishing up the details using drybrush.

Special Techniques and Textures

Watercolorists often use more tools than just brushes and paint to produce realistic renderings. There are many "tricks" to creating just the right look for pebbles in the sand, rough bark, and white clouds, among other things. These special techniques are all simple methods that result in a beautiful array of complex textures and patterns.

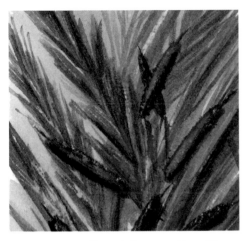

SCRAPING Use this technique to retrieve thin lines of lighter values. Start with a wash of color, and then use a pointed or beveled tool, such as a brush handle or dull kitchen knife, to scrape away a thin line of the wet paint and reveal the lighter value underneath. In the example above, the highlights of the cattails and grass blades have been scraped out. For this technique, the paint should be fairly damp but not too wet.

USING SALT Use the salt technique to create dynamic, eye-catching backgrounds for still lifes or to depict a starry night, a sunlit ocean, autumn leaves, or fluffy bird feathers. To accomplish this effect, sprinkle salt on the paper while the paint is wet. Let it dry completely, and then brush off the salt. The salt absorbs the paint, producing unique mottled effects, as shown in the example above.

SPATTERING To produce a speckled effect, load a flat brush with paint. Hold the brush over the paper, and strike it against your finger. The paint will fly off the bristles onto the paper. You can also load paint on a toothbrush and run your thumb over the bristles. Protect the areas you don't want to spatter with newspaper or cardboard. You can spatter with one color or combine multiple applications of color, as shown.

USING ALCOHOL Alcohol repels watercolor paints. Thus, when a bit of alcohol is dropped into a wet wash, unusual, exciting shapes and textures can result. This technique works best on smooth paper. Here alcohol was dropped into a still-wet wash of yellows, reds, and burnt umber to produce a startling effect.

LIFTING COLOR This technique can be used to lift out either highlights or "mistakes." While the paint is still wet, press a crumpled tissue or paper towel into the paint. You can dab or wipe the tissue to lift out color, as shown above, or you can leave the tissue or paper towel in place, removing it when the paint has dried. The texture that results can be used to create a variety of surfaces. (You can also use a damp sponge or paintbrush to lift out color from dry paint.)

LIQUID FRISKET Traditional watercolorists do not use white paint; instead, they save the white of the paper. To do so, you can simply paint around the areas you intend to keep white. Or you can use a liquid mask, paper frisket, or wax (such as a white wax crayon) to repel the paint. Here liquid frisket was stroked on the paper before applying the paint.

Lesson One: Sunflower

by Caroline Linscott

The colors used in this sunflower painting are analogous. But the similarity of the colors doesn't produce a flat, uninteresting painting. Instead it creates a sense of unity and harmony that's difficult to achieve with high-contrast subjects. This painting illustrates how to vary the values within a group of cool colors to convey a sense of stillness and quietude.

SKETCH Plan out your painting with a simple, rough pencil sketch of the flower and leaves. Always use a light touch when drawing on watercolor paper; you want pencil lines that will erase easily when you've finished painting, without leaving behind any grooves.

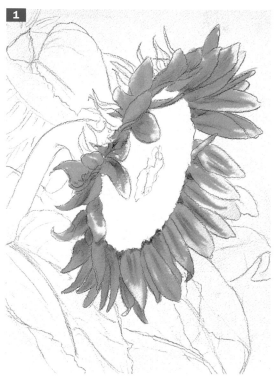

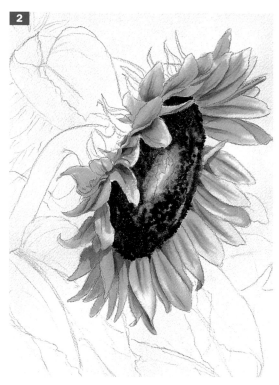

STEP ONE First wet the petals, working clear water deep into the paper. Then use your round brush to apply watered-down lemon yellow to each petal, working from the inside edge out. Leave some areas of the paper white for highlights. While the petals are still wet, use a lemon yellow and yellow ochre mix to shape the base and center of each petal. Let the paper dry completely, and then mix yellow ochre and burnt sienna to paint the spaces between the petals, using a little less water and more pigment in the mix under some of the petals to create depth. Rinse your brush, blot it on a paper towel, and then blend the areas you've just painted until you achieve smooth transitions of color.

STEP TWO When dry, use a mix of yellow ochre, burnt sienna, and magenta to add shadows. Then wet the paper around the outer edge of the sunflower's center, but leave the middle dry. Apply both yellow ochre and a mix of lemon yellow and yellow ochre around the dry center, using less water to create rich, dark colors. As you near the base of the petals, gradually add a mix of magenta and lemon yellow and a mix of burnt sienna, magenta, and ultramarine to your colors to darken them. Use even less water to create your darkest value where the petals meet the center. Sprinkle salt on the center while it's still damp, and then carefully brush it away when the paint dries to reveal a mottled texture, suggesting seeds.

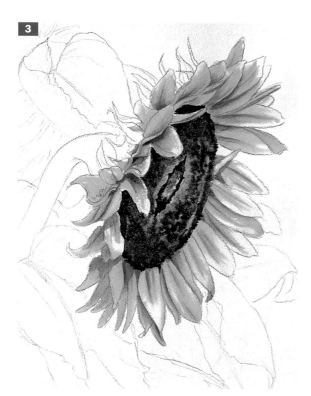

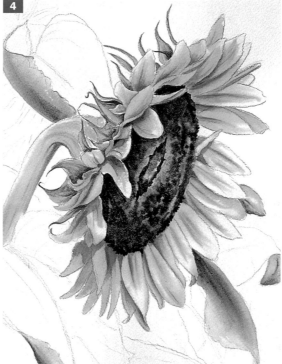

CHARGING IN COLOR
When you apply a new color to wet paint, it's called "charging in"; the paint will naturally spread and blend, appearing almost as if you had applied a graded wash. To begin, first wet each leaf, and then wash in a light green mixture of lemon yellow and cerulean blue hue. While the paint is still wet, apply a mix of lemon yellow and ultramarine toward the base and along the outside of each leaf. Next charge in a light value burnt-orange mix of yellow ochre and magenta along the outside edge. Instead of outlining the leaf with this color, just lightly touch the tip of the brush to the paper here and there to drop in the new color.

STEP THREE Now finish the center. Start along the center's edge with yellow ochre and a mix of lemon yellow and yellow ochre, as in step two. Then add a green mix of ultramarine and lemon yellow at the very center. Mix burnt sienna, magenta, and ultramarine to paint a dark rim where the center meets the petals, separating the two sections visually. While the paint is still damp, sprinkle salt over the middle. When dry, gently brush away the salt to reveal the textured area.

STEP FOUR Wet the undersides of the large, curling leaves, and then stroke a graded wash of lemon yellow mixed with cerulean blue hue along the outside edges, working from the darker outside edge of the leaf toward the lighter center. While the leaf is still wet, darken the center with a mixture of lemon yellow and ultramarine. Next wet the smaller leaves and paint them in the same manner, working from light to dark. Also wet the stem and start painting it with the lemon yellow and cerulean blue hue mix, and then add a dark green mixture of yellow ochre, burnt sienna, and ultramarine to the underside (see Charging in Color at right).

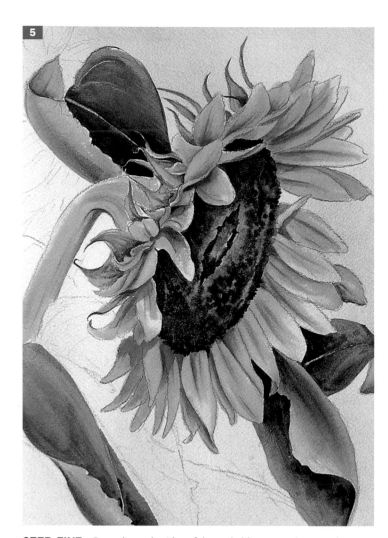

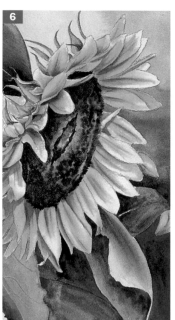

5

6

STEP SIX For the background, work ultramarine into the area at the bottom of the paper behind the leaves. As you work up toward the top of the painting, gradually lighten the values by using more water and less paint. In the background area at the left, wash in a light mixture of lemon yellow and yellow ochre. While this area is still wet, add some soft leaves in the background with a green mix of lemon yellow and ultramarine.

STEP FIVE Once the undersides of the curled leaves are dry, wet the top of each leaf. Then work in varying values of green, from the lightest (lemon yellow and cerulean blue hue) to the darkest (yellow ochre, burnt sienna, and ultramarine). While the paint is still damp, drag the tip of the handle of your brush through the leaf to scrape out color and create veins. If the paint is very wet, this technique will produce dark lines; if the paint is only damp, it will create soft white lines.

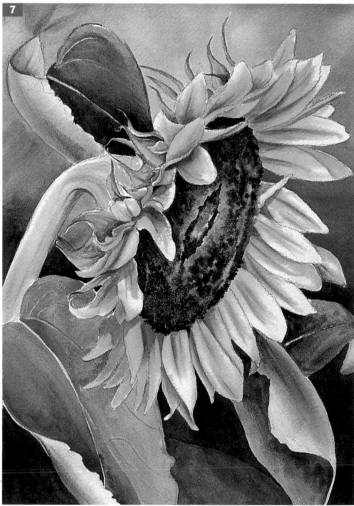

7

STEP SEVEN When dry, paint over the background with a second wash of a dark mix of yellow ochre, burnt sienna, and ultramarine, thinned with more water toward the bottom. Then add a mostly transparent blue wash over the small background leaves. Let the painting dry between washes.

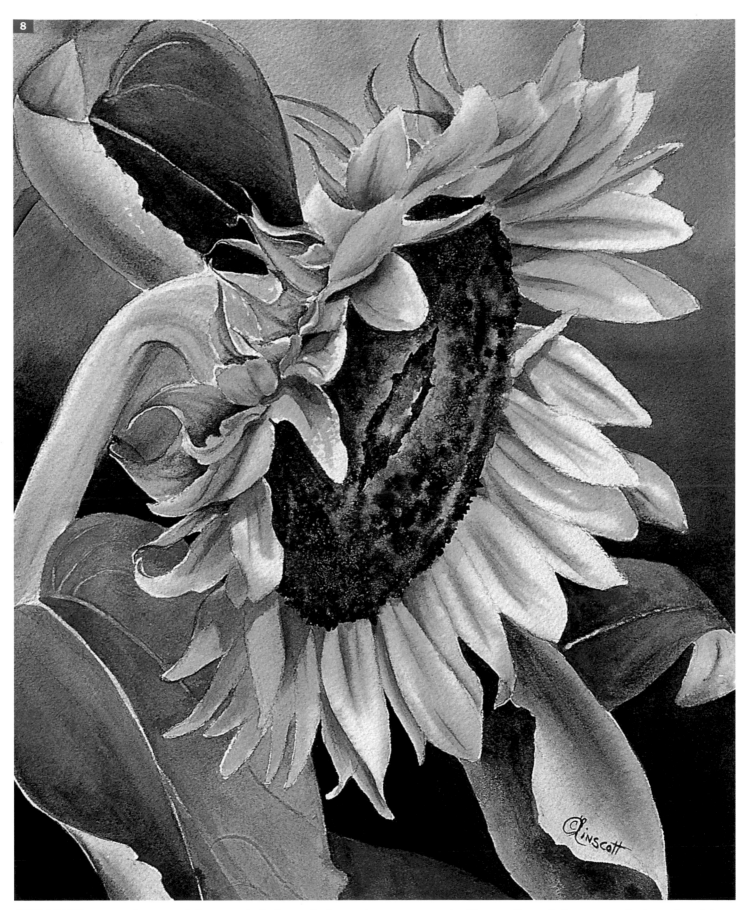

STEP EIGHT Now apply a series of glazes over the background. Alternate between a green mix of lemon yellow and ultramarine and a deep value of ultramarine, letting the color dry between each application. Toward the bottom of the sunflower, use very dark colors, lightening the color with water as you work upward. Let your painting dry, erase any stray pencil lines, and sign your beautiful work!

Lesson Two: Rooster

by Caroline Linscott

In watercolor, discovering what *not* to paint can be just as important as learning how to paint. This rooster requires a lot of white; and in watercolor, that generally means saving the white of the paper as you lay in your color. In this painting, you'll learn how to use darker values around the white space and lighter values to create the illusion of form.

SKETCH It's always a good idea to take an extra moment to prepare before you paint. Thinking ahead—and sketching out your ideas—will help you save time and make your painting go more smoothly. Begin your sketch with a border around the edge of your paper. Then draw the rooster inside this area, letting his feet overlap the border. Next, block in the "frame," inner design, and checker-board pattern. (You may want to use a ruler to keep your lines straight.)

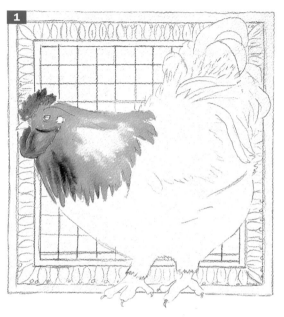

STEP ONE Working with a round brush, apply diluted yellow ochre over the majority of the head and neck, switching to a watered-down mixture of magenta, yellow ochre, and lemon yellow for the comb and wattle. Let the yellows and reds blend on the paper where they meet, but be sure to leave areas of white paper for highlights. While the paint is still wet, add the orange chest feathers with a mix of magenta and yellow ochre, stroking downward from the rooster's head. Let the paint dry.

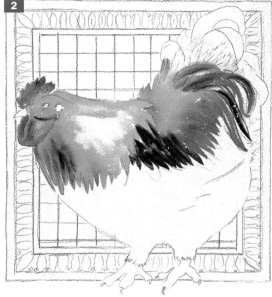

STEP TWO Load your brush with clear water and work it over the middle of the rooster's back until the water is well absorbed. Then lay a diluted wash of yellow ochre over the rooster's upper back and the long lower tail feathers. Blend a light mix of magenta and yellow ochre along the upper edges of the back area; then paint the feathers along the lower edge of the back, tapering the strokes from the tip of the feathers toward the still-damp yellow ochre area. Using less water, paint the long, reddish-brown tail feathers with continuous strokes, starting at the tip of the tail and working toward the body. With an even drier mix, paint the middle area of red feathers, leaving white paper for highlights.

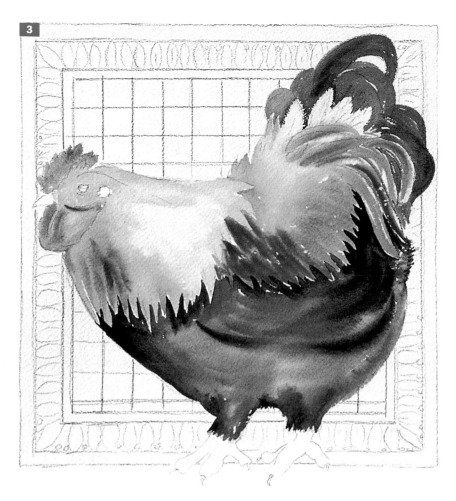

STEP THREE When the paint is dry, wet the lower body. Stroke a damp brush loaded with a mix of ultramarine and burnt sienna in the natural direction of the rooster's feathers. Beginning under the breast and working backward up into the long upper tail feathers, use the tip of your brush to cut color in, under, and behind the yellow and red feathers, leaving gaps of white paper for highlights. For the larger body feathers, first charge in a reddish brown mix of magenta and burnt sienna near the tail. Then, for the dark blue feathers along the body and at the top of the tail, use a mix of ultramarine and burnt sienna. Work the tip of your brush outward from the rump and around the legs for a fluffy, feathered look.

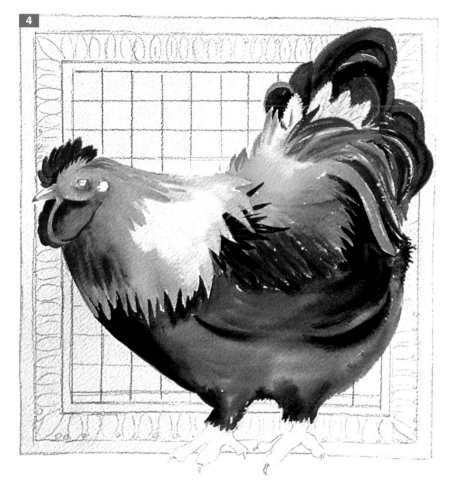

STEP FOUR While still damp, accent the tail feathers with deeper values of the reddish-brown and blue mixes used earlier. Define the lighter feathers around the neck by painting the dark blue feathers behind them. Then blot off some paint from your brush and start long, fluid strokes for the longer feathers on the lower body and tail, cutting in behind the white tail feathers with the tip of the brush. Start each stroke at the tip of the feather and quickly work back into the wet area around the white feathers. Use some drybrush strokes on the longer feathers to add variety and texture. Then, stroking toward the face, use a darker value of yellow ochre to distinguish feathers on the rooster's head. Also add a darker value of the red mix of magenta, yellow ochre, and lemon yellow from step one to build up the deep color of the comb, wattle, and red tail feathers.

STEP FIVE With the blue mix of ultramarine and burnt sienna, paint the feathers between the neck and back. Paint one side of each feather at a time, letting the reddish brown undercolor show in between. With a darker value of the red mix, define the red feathers at mid-back by deepening the value near the edge. Then use the tip of your brush to pull some of this color into the red rear tail feathers.

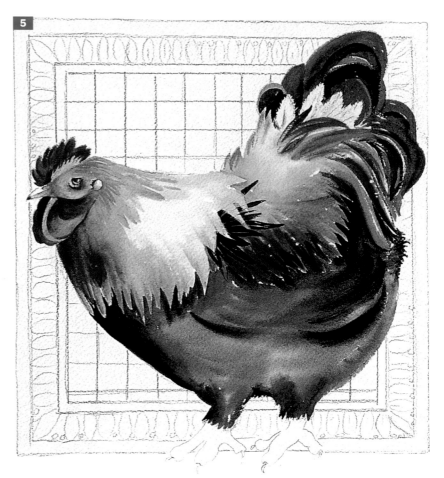

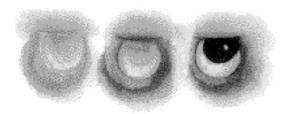

EYE DETAIL Working wet-into-wet, apply lemon yellow around the top and blend. While still wet, add yellow ochre at the top and blend downward. When dry, use a mix of ultramarine and burnt sienna to darken the outside edge, blending toward the center with a damp brush. Shade around the eye with a mix of magenta, yellow ochre, and lemon yellow. Then, when dry, paint the pupil area with a dark mix of ultramarine and burnt sienna, leaving a small highlight.

STEP SIX Now wet each foot. Add a small amount of burnt sienna and yellow ochre around the outside edges, blending the colors with circular brushstrokes. While the feet are still wet, apply a dark blue-gray mixture of ultramarine and burnt sienna in the shadow areas. Then load the same color on a damp brush to paint the toenails on the dry paper, leaving plenty of white on the light-colored toes.

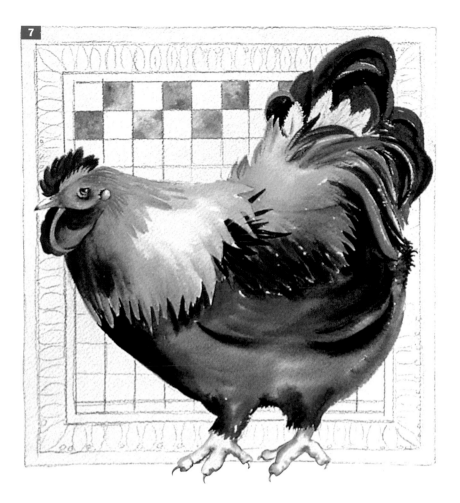

STEP SEVEN Paint every other check in the background with a gray-green mixture of cerulean blue hue, yellow ochre, lemon yellow, and a touch of burnt sienna, keeping your brushstrokes fluid. For a lighter, textured appearance, blot the wet paint with a paper towel.

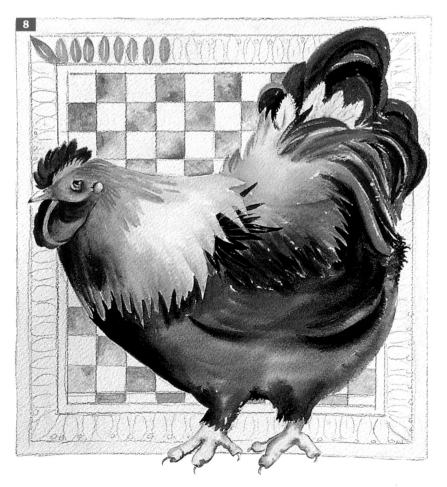

STEP EIGHT Use your round brush and pure yellow ochre to paint the petal design on the border. If you're right-handed, work from left to right; if you're left-handed, start at the right and work left. This way you won't accidentally smudge the wet paint with your hand.

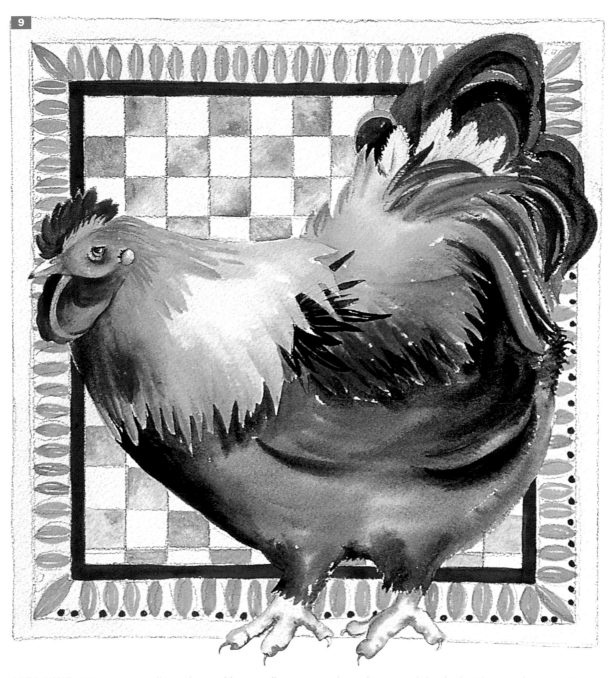

STEP NINE Mix magenta, yellow ochre, and lemon yellow to paint the outline around the checks. Then use the same mixture to add the red dots between the yellow ochre petal shapes.

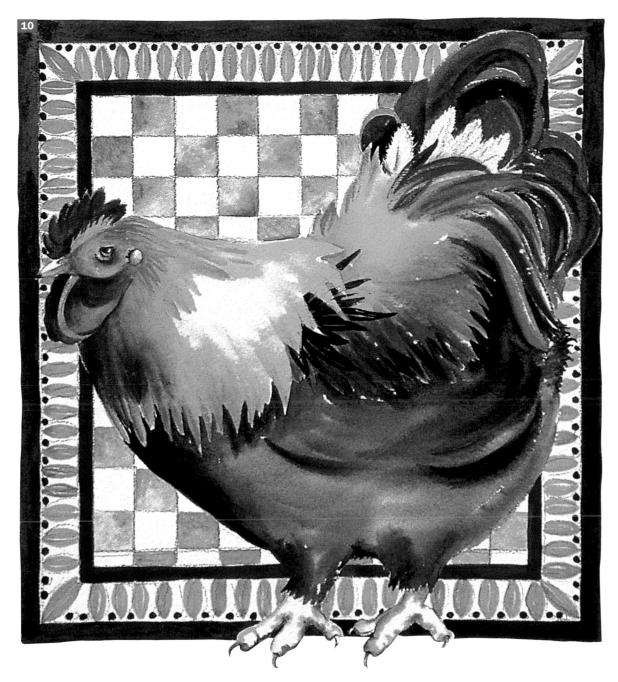

STEP TEN Now use a dark blue mixture of ultramarine and burnt sienna to paint the outside line of the background. Stroke in one direction, and let your first coat of paint dry completely before adding a second coat; this will darken and smooth out your brushstrokes. When your painting is completely dry, erase any visible pencil lines and sign your name!

Lesson Three: Depot

by Caroline Linscott

Just because you're painting with watercolor doesn't mean all your colors must be watered-down and weak. In fact, you can add interest and excitement to a painting when you contrast light, watery colors with dark, less diluted colors.

The viewer's eye is automatically drawn to the richer, thicker color, but the less vibrant shades and lighter values—along with the tranquil white of the paper—make the other colors that much more striking.

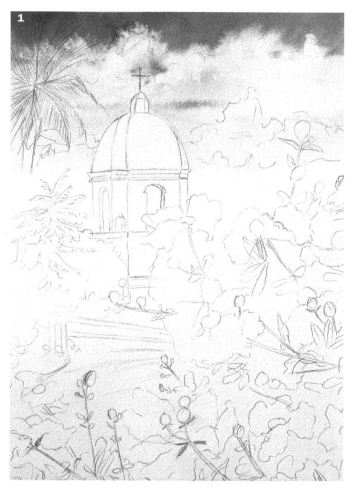

STEP ONE Before you begin painting, work out the size relationships, shapes, and angles of your composition in a sketch. Then wet the sky area, working around the building but wetting the background vegetation thoroughly. Starting at the top of the paper, stroke in cerulean blue hue with a flat brush, painting around the white clouds. Rinse your brush before brushing ultramarine over the lighter blue, letting the colors blend on the paper. Lightly press a tissue or paper towel against the white sky to lift out some soft cloud shapes; then soften the edges with a clean, damp brush. Next stroke the sky colors through the clouds and behind the dome, and then add a light wash of yellow ochre at the base of the clouds.

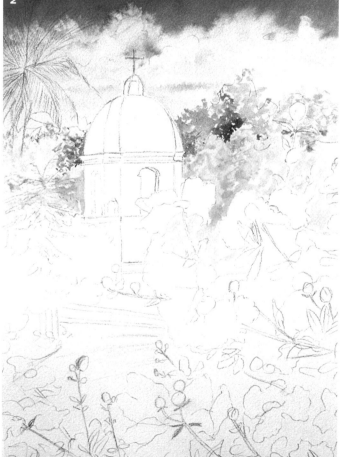

STEP TWO While the sky is drying, mix a pale yellow-green with cerulean blue hue and lemon yellow. Lightly dab in this color for the distant trees, letting some of the white show through. Let this area dry completely. Then mix cerulean blue hue with magenta and paint the purple trees in the background with the same light, dabbing brushstrokes.

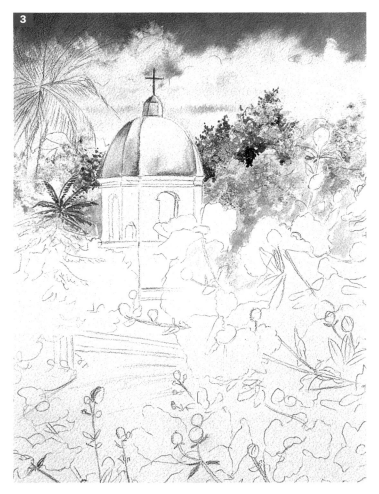

STEP THREE To create texture in the foliage, dip your damp sponge into the yellow-green mix and dab it over the trees, turning it frequently for a varied pattern. Sponge over the purple trees, and then use your round brush to paint the branches. Now use your brush to work a new mix of yellow ochre and cerulean blue from the tips of the palm leaves toward their centers. Then wet the dome and apply cool gray shadows with a diluted wash of cerulean, ultramarine, and burnt sienna. Use more water as you work from the left side of the dome toward the right, leaving the far right edge white. At the same time, add warm shadows with a mix of yellow ochre, burnt sienna, and a touch of magenta. Paint the cross with the cool gray.

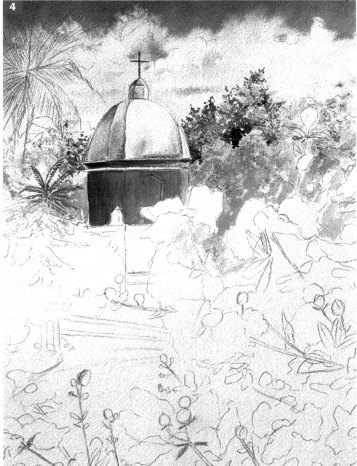

STEP FOUR Paint the brick section of the depot with a mixture of yellow ochre, burnt sienna, and magenta, using more paint and less water to achieve a deep value. Follow the same gradation of color you used on the dome: Paint from left to right, gradually adding more water to your mix to lighten your color as you approach the sunlit side of the building.

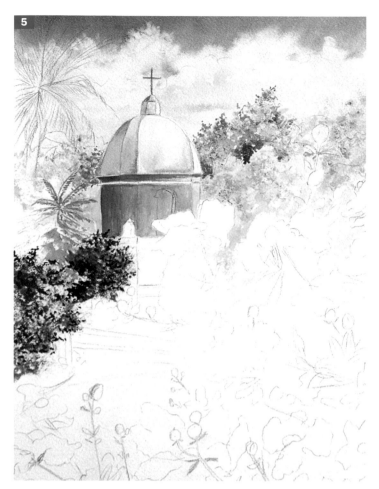

STEP FIVE Now use your clean, damp sponge to alternately dab magenta and a mix of magenta, yellow ochre, and lemon yellow over the red bougainvillaea bushes. Be sure to turn your sponge often to vary the pattern as you paint, and try to leave plenty of the white of the paper to give the impression of individual flowers instead of one large mass. Next add the bottom section of the small palm tree using a round brush and a lighter value of the green mix used for the leaves.

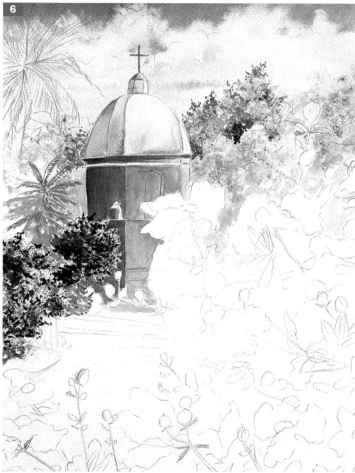

STEP SIX Mix a light value of an earthy green using lemon yellow, ultramarine, and burnt sienna, and then wash this over the greenery behind the small palm tree. Create a little deeper value of this mix by decreasing the amount of water in the mix, and then use it to add some soft fronds surrounding the palm. Then sponge in a small green bush in front of the bougainvillaea with the same mix.

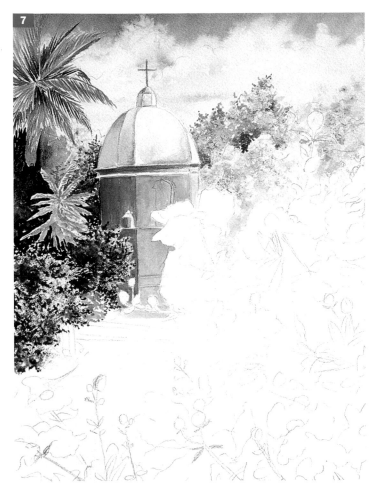

STEP SEVEN To paint the branches of the taller palm, mix a light yellow-green with lemon yellow and cerulean blue hue; a medium, earthy green mixed with lemon yellow, ultramarine, and burnt sienna; and a dark, blackish green mixed with ultramarine, yellow ochre, and burnt sienna. Stroke in the center vein of each leaf; then use the tip of a round brush to paint each frond, starting at the outside edge and stroking inward. Alternate the greens as you paint, working from light to dark. Paint the trunk with burnt sienna, and sponge deep shadows into the trees and foliage with the two darkest greens. While the paint is still wet, sprinkle salt below the tall palm, and gently rub it off when the paint dries.

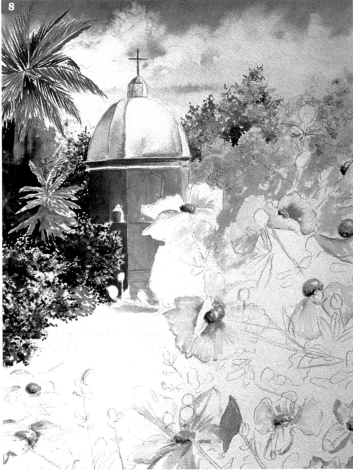

STEP EIGHT Now paint the foreground, starting with the yellow centers of the flowers. Begin with a light value of lemon yellow, saving the white of the paper to create highlights in the upper right of each flower center. Then add a little shading with yellow ochre. Follow this with a darker shade of orange, mixed with lemon yellow, yellow ochre, and magenta. Finally add the darkest shadows with burnt sienna. To create shadows on the white petals, use a watery, transparent gray mix of cerulean blue hue, magenta, and ultramarine, leaving a substantial amount of white for the lightest areas of the flowers. Since the petals are mostly white, be aware that what you don't paint is more important than what you do paint.

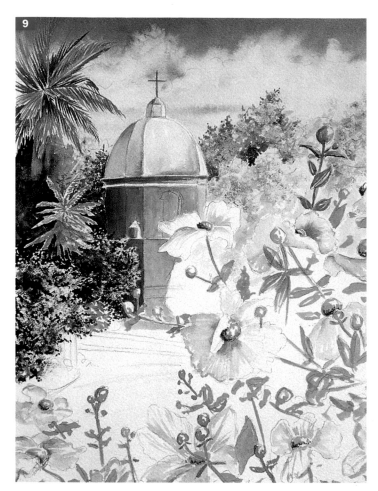

STEP NINE While the flowers are drying, paint in the stems, leaves, and buds with medium and light values of yellow-green (a mixture of lemon yellow and cerulean blue hue). Be sure to save some white areas for the sunlit highlights. The muted values of these white flowers and their greenery provide a strong contrast to the bright bougainvillaea and the rich color of the depot walls. This contrast makes the depot really eye-catching because the bright, warm colors "pop out" against the cool, more muted colors of the background.

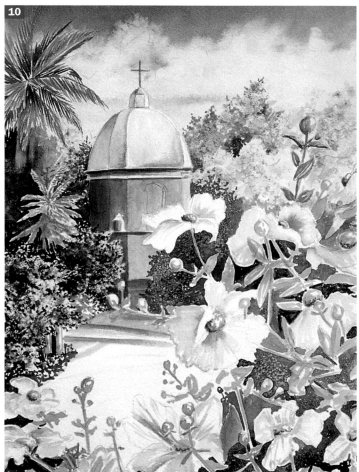

STEP TEN With a round brush, use the greens from step seven to carefully paint light strokes up into the background trees, creating dark shadows behind the foreground flowers. Randomly sprinkle on some salt as you go to add texture. Now paint the posts under the bougainvillaea with watered-down burnt sienna. Then, with a mix of cerulean blue hue, magenta, and ultramarine, shade the posts and lay in two lines for the railroad tracks. Next apply several glazes, to the shadow areas of the building with a darker value of the brick color. Allow each coat to dry before applying the next.

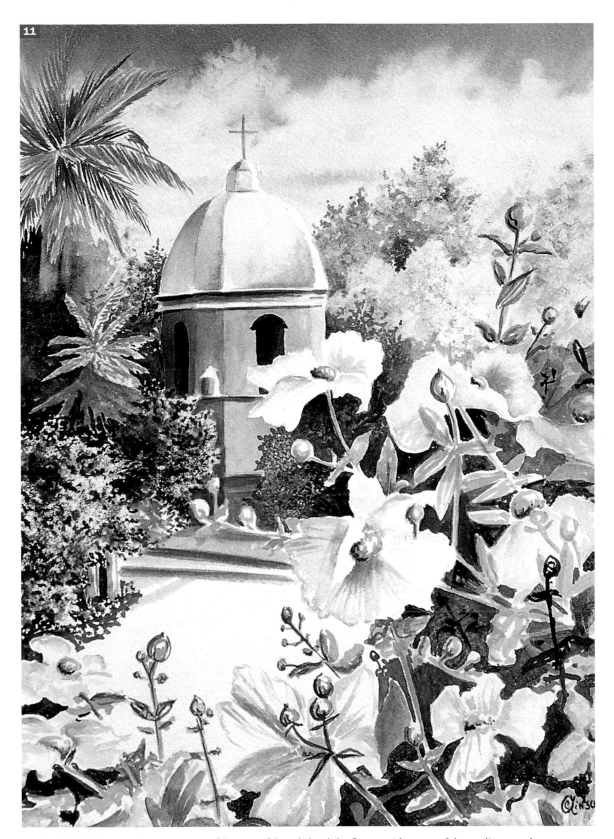

STEP ELEVEN Now glaze over some of the green foliage behind the flowers with a coat of the medium, earthy green. Also add some of the dark, blackish green here and there to help define the flower stems, leaves, and buds, softening any hard edges with a damp brush. Start painting the dome windows from the top down with a thick, dark mix of ultramarine and burnt sienna. About halfway down, clean your brush, and then paint the brick color from the bottom of the windows up. Let the colors blend where they meet to create the illusion of bricks showing through the dark windows. When your paint is completely dry, erase any visible pencil lines and sign your painting.

Lesson Four: Landscape

by Joan Hansen

This beautiful spring scene is an excellent exercise for practicing a variety of watercolor techniques. As you paint, you'll learn how to render reflections in water, colorful foliage, and a clear blue sky. And this painting also provides a good lesson on how to create depth and perspective on a flat surface.

STEP ONE Lightly sketch the basic shapes of the scene on your watercolor paper. (Quick sketches are a good way to make sure your composition is visually interesting before you start painting.) Note that the horizon line—the point where the water meets the sky—is above the center of the paper in this composition. The high horizon emphasizes the foreground of this scene. Load your flat brush with clean water and dampen the sky area only, making a crisp edge along the horizon. Then wash over the sky and sea with both ultramarine and cerulean blue, leaving some white areas to suggest clouds. Add a light wash of cerulean blue hue near the horizon line, blending where the sea meets the sky. Let dry, and then use a transparent glaze of yellow ochre to create the appearance of low clouds. Repeat with magenta as shown.

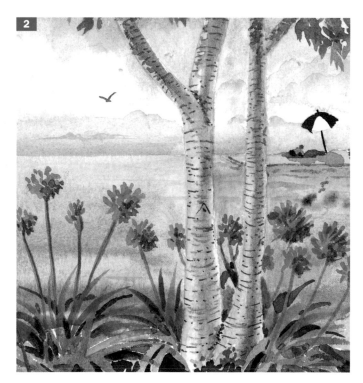

STEP TWO Brush clear water along the trunks of the two trees in the middle. Then wash a small amount of yellow ochre along the edge of the trunks, letting the color bleed toward the center. Next, mix ultramarine and burnt sienna to create a neutral gray, and apply the color in long vertical strokes with a round brush, just to the right of the trunk's center. With the tip of the brush, add small lines across the trunks. Curve them slightly upward below the horizon line and slightly downward above the horizon line.

STEP THREE Use a flat brush to paint a variety of pale washes for the foreground flowers. Let the area dry; then, using water sparingly, mix more vivid and deeper shades of the same washes. With the tip of a round brush, lightly dab on more intense, brighter shades to give the flowers a bushy appearance and bring vivacity to the floral bank.

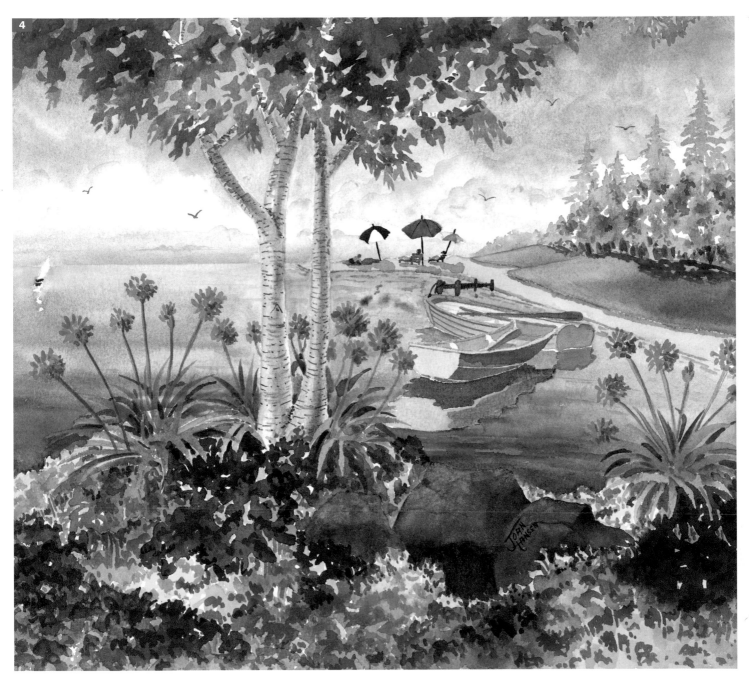

STEP FOUR To paint the trees in the upper right corner, mix a variety of greens with different amounts of ultramarine, lemon yellow, and yellow ochre. Use the round brush to paint the foliage, starting with the lightest color and working up to the darkest values. To create the effect of sunlight on the leaves, dab in some tiny highlights with lemon yellow. Then paint the sea with the same wash technique used for the sky. Wash in some yellow ochre just below the horizon line with a flat brush. Add the boats, keeping in mind that their reflections appear darker in the water and that the edges also are skewed. Paint a light wash of yellow ochre and ultramarine for the beach; then paint the umbrellas and people any colors you desire. When the painting dries, erase any visible pencil lines—and enjoy your work!

Lesson 5: Seascape

by William F. Powell

This painting of rough rocks and smooth surf illustrates how you can create depth and texture by starting with a layer of initial color, or an *underpainting,* and then building up subsequent layers of color. The washes are vital to creating form and texture. Then it's the darker values that define the shadows, producing a sense of depth and dimension as well as the variations of light and dark that appear as patterns or textures.

STEP ONE Start with an underpainting for the ocean in the background, using a wash of ultramarine, yellow ochre, and cerulean blue hue. The underpainting serves as a base that will show through subsequent layers of color. Apply a thin wash of cerulean blue hue mixed with yellow ochre for the breaking wave, and paint very diluted washes of ultramarine and cerulean blue hue for the tumbling foam. Leave some of the white of the paper for the lightest areas. Then mix ultramarine and a little burnt sienna for the shadows under the foam.

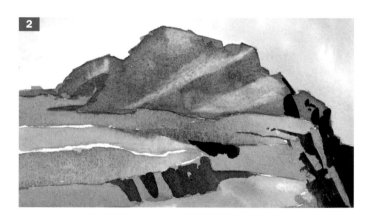

STEP TWO Next apply an underpainting to establish the mass of rocks. Use a variety of thin mixtures of burnt sienna, ultramarine, cerulean blue hue, and magenta to develop the major planes of the rocks. Once the undercolors are dry, add a few shadows and details using deeper values of the same color mixtures.

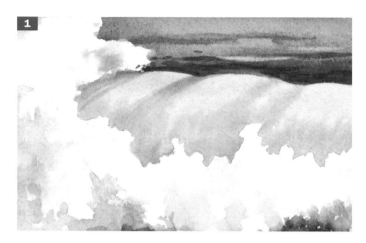

STEP THREE The undercolor for the sand is a mixture of yellow ochre and burnt sienna. Add a little cerulean blue hue for the grayer areas of the sand, and add ultramarine to the mix for the wet sand. Paint the pools of shallower water using the same washes, adding pure cerulean blue hue occasionally and leaving some areas of white. Then paint the rocks with the same mixtures used in step two. Since rocks are darker when they're wet, deepen the color value at the bottoms, where the rocks touch the water. When the paint is dry, scrape out the white highlights with a craft knife.

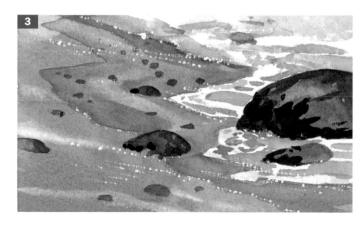

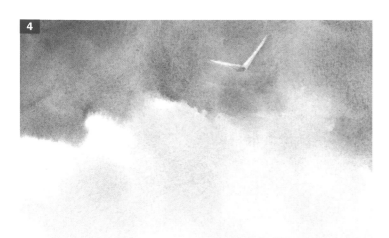

STEP FOUR To paint the sky, brush an even layer of clear water over the area. Then wash in ultramarine and cerulean blue hue. The colors should bleed readily into the water, creating soft edges. For the clouds, use cerulean blue hue with a touch of yellow ochre, and tilt the paper so the colors flow freely. When the paint is semi-dry, use the tip of a clean, slightly damp brush to draw the shape of the sea gull. This "thirsty brush" draws color off the paper, making it lighter. Then scrape out the highlights on the wings.

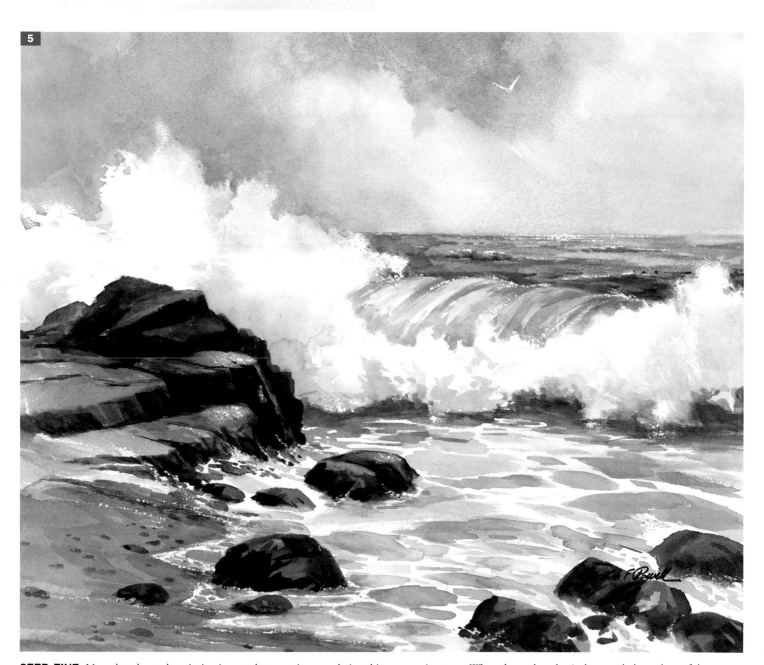

STEP FIVE Now that the underpainting is complete, continue rendering this seascape in stages. When the undercolor is dry, use darker values of the same colors to create shadows and suggest form and depth. Once the subjects are well established, add final details with the tip of the round brush. To finish, use a craft knife to scrape out the tiny white sparkles and the final highlights.

Conclusion

Watercolor is a wonderfully versatile medium. As you continue to work with it, you will discover even more interesting effects and techniques to use in your paintings. Practice and experimentation are the only ways to become truly skilled with this medium. And making mistakes allows you to improve your skills—so don't be afraid to try new things!

What you achieve with your watercolors depends on how you choose to use them. Try painting on different surfaces, textures, and colors of paper. You might develop an approach that is entirely unique. Study your subjects, and then decide the best way to approach them.

Finally visit art galleries and see what other artists have accomplished with watercolor. We hope you have learned many ways to create beautiful art through the painting exercises in this book. Good luck!

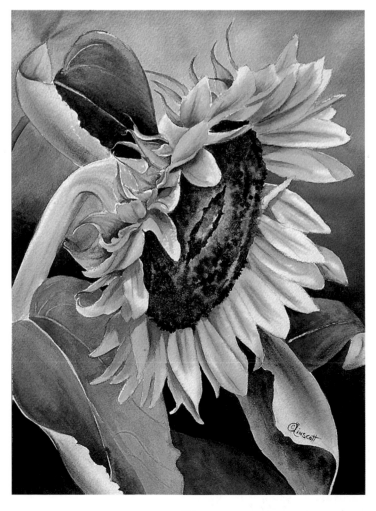